Cezanne Was A Voyeur

1. Pastoral
Lincoln, Nebraska. Summer, 2015

2. The Stylite
Albuquerque, New Mexico. Summer, 2019

Pastoral
Lincoln, Ne 2015

Much Less Than an Acre of Eden

Lawn darts thrown high in the air come down like proclamations on an unkempt and wild patch of Earth which was our paradise. My mother picking strawberries while an oldies station plays Marvin Gaye's 'I heard it through the grapevine' and it's 1985 and everything's ME ME ME in this Walkman generation but it's all so Holy and biblical as Reagan holds a nuclear bomb over our heads and every day could be our last. Playing with rollie pollies, collecting them like multi-limbed gems, watching them search for safety in themselves and relying on their armor to save them from children both curious and cruel in their innocence. The dirt and grass and all things living were the size of peaceful giants, a dead race long forgotten.

Searching for some notion of truth at night with the Delgado kids across the street, playing Ghost in the Graveyard while fireflies flickered like fluorescent light bulbs and even then we were searching for the spirit, the spectral warm internal glow of a humid Midwestern summer before school became a reality and duty and paper routes and part time jobs locked us into the machine.

This was our heaven. I drive past it sometimes, just to see if my belief in the good of all things turned out to be true. My answer is always affirmed by the pine fence that surrounded our backyard when we were kids and surrounds it now, keeping all the good stuff locked up tight behind property lines and the bad stuff out and I hope that girls and boys still cause a racket on that little piece of land, kids still foolish and wise enough to *believe*.

For Thomas Merton

Generic hamburger helper in the fridge a la

Monsanto and who can afford to be moral when

you're starving? Fifty bucks on my food stamp card.

The bread awaits, the meat awaits, the sodium bloat

of belly awaits, metabolizing slowly to equal out my

vitals. I yearn for asceticism but my God do I love

the taste of black forest ham with horseradish!

Food Bank Poem

Girls in gowns with men to match in suits of crimson and black, glower devil as the hungry shuffle down the stairs for the boxes full of food that nobody else wants. I come in late while everybody is already seated. Numbers are given out. My number is 54, printed on laminated blue construction paper. The Russian old ladies in scarves and floral dresses. Koreans in baseball hats and simple shirts. Somali children talk amongst themselves. The white Midwesterners that were too proud to beg (a privilege), but so hungry they gave up the game, are now here to surrender to empty bellies, scurvy and brittle bones.

The microphone is off today because of the wedding going on upstairs. We are told to keep our voices down. This sparks dissent. There is a crackle of riot as the kind woman's voice whispers out numbers for the food line, a timid voice that has never screamed or shouted. A ball capped lesbian feels empathy and echoes with a boom, her big hands cupping her mouth bullhorn style.

Two women sit behind me, rebellious even in middle age, complaining about the line, the food and other people while their electronic gadgets beep and whir every two minutes and cause the crowd to thunder a SHHHHHHH, communal air escaping between pursed lips in their direction. The women laugh and giggle, joke amongst themselves. Unaffected. They have no shame. Those of us in survival mode do not know the luxury of a thing called 'shame'

My number is called. I rejoice internal, springing from my seat. I'm near the end of the line and there's not much food left. Some rotten fruit is dumped in my box. I notice dwarf mangos and red Asian pears sitting lonely, neglected. I ask for them and the old man behind the table is so happy that someone wants this strange fruit that his grim lips smile. Parsnips, rutabagas and turnips sit lonely as well. I stuff my box full, feeling my inner child share the despair of being picked last for the team, my common thread with these archaic vegetables. Later down the line I save polenta, pumpernickel bread with walnuts and other odds and ends, all rejected by the masses but cherished by me. At the end of the line the American in me grabs a package of gooey donuts, almost on instinct alone.

My arms are full. I'm planning out feast after feast in my head. I walk up the church steps, glance through the glass window of the cathedral at the wedding party and everyone is so beautiful. Perfect. Polished. Hair and teeth gleam like diamond, the bride and groom in mutual swoon. They're so very beautiful.

I feel envy. My doubtful heart sags a bit. But my arms are full, and soon my stomach will be as well. My bruised fruit is beautiful. My wilted and limp vegetables are beautiful. My crusty bread is beautiful. My heart escapes my gut, shaking off the acid like a dog in a sprinkler.

I squeeze my treasures tight and walk home with a smile on my face. A song more beautiful than any hymn throbs my acoustic skull.

Our Daily Greed

Basil plant, gargantuan upside-down chandelier of fragrant green. Should make some pesto soon. Making hoppin' johns in the crockpot, should last me the rest of the week. Tostadas will break the mush factor a little bit, yellow communion wafers the size of small plates. I'm full. Just ate lunch. The pesto will wait for another day. The luxury of 'waiting' for food, instead of 'starving' for food. I suck on my lemonade, the sour twinge making my face scrunch, but not enough to break my shit eating selfish American grin.

On Having a Stroke and Finding a Lump in the Breast within the Same Month

Lady Magdalene and Joan,
female warriors and misunderstood women
rest under my skin like cremated history sits in a
tomb.
> (Stench of dirty flesh, a reminder that I'm
> human
> and part Alabama French.)

I'm propped up like a blood filled betsie wetsie doll
in a wicker rocking chair that lacks motion
awaiting my lover's return.

She's at work.
I'm dying.
She's dying.
I'm at work.

The women resting under my skin are dead.

This woman resting under my skin is alive.

But why is her heart not pumping?

or aching?

or breaking?

Saints rest under my skin. I scratch at my flesh, unkempt fingernails leaving violent red tracers, trying savagely to awaken these two women so that they can save these two women.

Thank You

Walking high headed and confident across the street. Purple lesbian sweatpants, tight shirt. I sidle up to the pop machine, plugging in quarters from the laundry fund. Push the Sprite button, trying to cut down on caffeine. Ka klunk tumbles down the green corn syrup, bubble and foam.

On the way back to my apartment building my neighbor pulls up in her old Buick and offers me a slice of rhubarb pie from a greasy spoon. How did she know, how did fate know, how did Elohim know that this was my favorite?!
I thank her, embrace her.
Run up the stairs, stand over the sink and eat the mangled red triangle like the slob I am.

All this beauty, all these riches, all this plunder, and still I have to search for gratitude?

I wipe my lips with a coffee stained rag, a rough kiss from a tarnished angel wing.

I look outside. The sky, unlike my mood, is blue.

Pills

The sun licks the baby blue jersey sheets, caffeinated and awake, not much tremble or shriek today. Science is horrifying and glorious like a sadistic god's love. My lover happy today, joking around and pulling faces at each other at dawn after a week of spit-rain and gray skies. New drugs with new side effects, medical industrial complex. They may experiment on rats but happiness blinds me to the torture of vermin.

My lover says my eyes smile now, not just my mouth curled at the lips.

Thank you, psychotropic stimulant, because I laughed at a glowing screen today, guffaw and shake of lungs. I eat a hunk of all beef sausage, salt and grease on my lips, leaving a film over my bottle of pop, oil spill.

I have food. I have love. I have my smile. Angels doctors lovers. I thank you from the bottom of my gleeful zombie heart.

Pass the Basket

Trees heave and seize up like drunks over the toilet,
intoxicated with prairie wind.
Instant coffee and nicotine, windows open.
The wind blows away my pages of self-help books,
dog eared and highlighted, reminding me to toughen
up a little.
I'm just trying to stay sober, ghost tongue of
Jameson smacks in my dry mouth. Nine years, not a
drop.
Window open, instant coffee and nicotine.
Much better than doors closed, the air banished by
Wild Turkey.
I haven't kissed a toilet rim with pubic hairs
encrusted in urine for quite some time.
The winds calm down and the trees sober up.

I pour a tall glass of ice water, and it tastes wonderful.

SSDI as a National Endowment for the Arts Grant

Frank O'Hara, James Baldwin, W.S. Burroughs and
Rimbaud lay on my bed, teeth-yellow paper legs
spread. Guess I've got a thing for dead homosexuals.
The money to buy books and the luxury to read
them. I suck off Uncle Sam's fat white tit. SSDI.
The crazy check comes once a month. I haven't
worked in over ten years. Let the checks come, the
food stamps, the healthcare, while I educate myself
on how to best destroy the government. I hope after
the revolution the library will still be open. I'd
rather read than work, rather write than kill. I won't
pick up a gun unless it's to do a magic trick, a la
Annie Oakley, target practice at an old dictionary.

Gallery

Dawn, pubis of trees in April, a good Nebraskan wind eradicating the gnats and making the birds' flight patterns more poetic. Filling myself up with lemon iced tea with sodium drops, smoking cigarette after cigarette. Acid of cheap coffee in my guts. My wallet sits by my side, waiting to empty itself into a random pizza delivery woman's hands when I'm too lazy to cook. It's got a little bit of money in it, enough for two pizzas. My dad bought a painting from me the other day, gave me twenty bucks, the price of the canvas. I didn't tell him it was a Christian themed piece. It would've pissed off his atheist heart if he found he had something in common with the Old Testament.

We talked about his funeral, like we've done a handful of times before. I think he's getting me ready more than himself. He has all the arrangements made and placed in a manila folder in his desk, waiting for me, the prodigal daughter, to open and organize and hopefully cry. He doesn't want anyone to speak at his funeral. He wants to be cremated. He doesn't want a headstone.

He tells me to organize his music files for him for the service. Some classical, some chamber music. I suggest Pete Seeger, his eyes light up, that special twinkle that reminds me that no matter all the violence in his house he was just an old hippie Union man doing his best. My father once told me that he thought life was a bitch and then you died. The sad part was he wasn't joking, a bumper sticker for an epitaph.

I've got twenty bucks in my wallet from a painting my dad hung the wrong side up, but I didn't correct him. You don't correct someone's viewpoint of a piece of art, the log in your eye like a telephone pole transmitting dyslexic. I won't correct you on the way you look at the painting, dad, but I do hope I one day correct you on the way you look at love, as soon as all the splinters have bored themselves with my retinas and fall away like a stack of papers that are supposed to sum up a person's life.

Bread and Roses

My lover wants me to go out to western Nebraska, North Platte, for Mother's Day. Mom, I need a break from your memory. Maybe we'll have ham, or turkey, or a greasy burger from Wendy's. All serving their purpose, the filling of the belly that can't be too choosy for its fuel.

Mom, deliverer and warmer upper of fast food, spending her disability check on two kids' pre-teen appetites. I want to celebrate you, but also to leech the pain out of my skin and bones.

My lover's mom just found out I was trans. My bald head, my deep voice. Nervous of comments, questions. Never mind all that, this isn't about me. It's about being asked to the table. Please let me sit at the table.

Help

There is a layer of black ice a quarter inch thick on I-80, the rigid stoic road that vivisects the Midwest. My lover is planning a journey from the star city of beatnik poems to the mysterious Nebraskan sand dunes five hours west.

I ask her not to go. I am terrified of her movement away from me, like always. It's Thanksgiving Day, a day of gratitude reframed from a day of theft. I send her warning signs and weather alerts bouncing frantic over satellites, from my mad heart to her calm ear.

I want her not to go. I want her all to myself, safe inside our central heat apartment under a plastic-down-alternative duvet, resting on a therapeutic mattress.

I am just short of begging. I light a candle for the strong lady saint who shares a name with a friend of mine long abandoned. Guadalupe, whose vestments remind me of fire and courage, and right now I'm so scared and honest that I don't care if I'm appropriating.

Goddess. Saint. Grant us both courage to accept each other's fear as well as strength and save us from the John Wayne stubborn death of many a farm hand.

It's burning for her now. I'm burning for her now.

5 AM

My lover sick and scrunched face beside me, her freckled back, her hips a hill in Sante Fe I can't remember the name of. Little tugs of her nonsmoker lungs. She breathes, curls, sighs. She is alive. Not a statuette or idol, not a character in a French novel where everyone dies. She just is. The lazy beauty of her stillness strikes my mouth devoid of the vowels to pronounce her name. I sidle my tomboy calloused foot against her smooth calf, a cricket singing its song.

Cezanne was a Voyeur

Swarms of yellow jackets bounce against my bedroom window, flutter of light speed wounds. I'm leaned up against the off-white wall, off balance fan motor in the a/c making the apartment tremble. Looking down the street, past the pool hall, the vacuum repair shop, old people's gym, meth pipe store and across a busy intersection.
Life awaits outside my picture window, green, tan, the automatic gun shot of primed gun metal cars.
I may open the door. I may not.

Pastoral (1)

Spastic scrawls of lightning, shaking the core ten seconds later. Spring downpour, the trees glow and sag under angels having a water gun fight. Nebraska. Prairie. Politeness. Storms that make my heart break in childhood memories. I'm in the right place.

Van Gogh in the Madhouse, Missing One Ear

Two birds, black, swoop like fighting lovers

over the billiards hall across the street.

April. Warmth. Green trees.

I scream psychotic, uncontrollable.

Three freshly planted daisies compliment the orange

lawn chair that supports my buttocks and

pockmarked back. Roky Erickson plays lonesome

and gorgeous and mad. I look at the lawn, dirty with

candy wrappers and empty forty-ounce bottles, filth

landmines. It is so beautiful, Elohim. This sunny

lazy day.

I scream psychotic once more, trumpet mouth.

Decaf in the Mr. Coffee machine gurgles in completion. Haze of Kansas, controlled burns making my nose itch and my eyes scratch, carried to my deck by the end of earth currents.

I scream psychotic, mumble medicated.

Cursing, always cursing, whispering into Vincent's lost ear.
I'm the Magdalene he offered it to, still bleeding in his fist.

Modern Olympia

Huck a cigarette off the terrace, fire flying like a dying mosquito. Cool early spring tongues my neck, ankles, scarred hands.

Everything in bloom in a little concrete patch swallowed by a parking lot, but growing strong and snotty, little rebellious teenagers. The sky is baby blue, white water paint for cumulus clouds. I sip decaf, read interviews by my favorite author. Kale and spinach troughs hang on for dear life, connected by wires and plastic, almost crushed by a hailstorm a week ago.

The sun warms my black denim legs, and I write digital words to ex-lovers, friends, created family members.

The houseplants are jealous of me, because I have the cancerous sun while they sit in shadows of black mold drywall. A car drives by, breaking the scenery. I sip coffee. I smoke. I read. The near dead planet still has a little hope left in her, and she bestows it upon me, the tenacious green of my heart.

Carrion

Dove, crow and vulture.

I claim all three,

though the cuckoo's constant promptness

hypnotizes me to a state of red at the moment.

The cardinal showed up yesterday,

its color the flight/escape of my insides.

The chickadee reminds my lover of her youth,

the size and texture of a doll's plucked pillow.

The pigeon shits on our doorstep

and reminds us that we're not that special.

I fear for the day when the hawk devours them all.

Pastoral (2)

Pubic triangle of cottonwoods, a small burst of green in a cornfield that stretches beyond my myopic driveby. The men on the tractors are out in force today, dust masks, anti-percussive earphones, baseball caps.

Little telecommunication crucifixes lace the edges of ditches. I pull into a bare field, feel like smoking store bought cigarettes and staring at nothing which is everything in the Midwest. I'm not there for over a minute before I catch sight of an old man on a tractor heading straight towards me, bearing down. I mumble oh-shits and fucks, put it in reverse to avoid a collision, quickly speed down the dirt road. The farmer pulls up to the end of the road, no longer in pursuit but his million-yard stare follows me down the road back to town.

'Damn city people', he thinks, 'thinking they can write poetry in a cornfield.'

I drive back to my apartment building and check the mail, full of books by east coasters and west coasters.

'Damn city people', I think, 'thinking they can write poetry in a cocoon.'

And we're both right.

Camille Pissaro was an Anarchist

Grass cut perfectly on the lawn of my therapist's office after a session, it's like nature's carpet. I've never seen grass so perfect besides when I was a kid at the put-put golf course. Waiting for my dad to come pick me up. I think I'm going to give up driving, already can't do it at night, can't see a sign five feet ahead of me. Macular Degeneration runs in my family, on the Southern Alabama side. French Impressionist vision.

When I was a young something a drive in the country meant escape, meditation, sex. Now I run chores to chain stores and gas stations to fill up my thermos with Dr. Pepper. This grass, so perfect, the prairie, so wild. I'm not so perfect. And nowadays I'm not so wild either.

Dirty Hands

Sun burning through the spf 55 lotion, my Irish skin
exploding like a cast iron pan in a microwave.
Reading L.A. poets, the sunny day draws me to them
for some obvious reason. When I lived in the
Southwest we had smog alerts all the time, but I was
a maintenance person which meant I had to do the
job whether it was shitty outside or not,
remembering the brown cloud over Phoenix.
Took a couple photos, the curve of a handicapped
parking space, the geranium red of the coca cola
machine. Construction workers blinded to the
beauty of the day by having to work on a sewer pipe,
twenty feet away from our complex.
I can't smell the shit but knowing it's there links me
closer to my humanity.

The sun heats up my crucifix, burning my Nebraskan permanent redneck. Chemical blue grass sprouts from a reclaimed old toaster like moldy bread. And like that non poetic white chemical bread, nature has once again made me wonder.

Pastoral (3)

2 hours before the lightning strikes, blush of cloud, drool of blue. Just went outside to get the mail, a photo book for my smart girl brain and a comic book for my dumb girl brain. Everything is calm and silent. No screaming neighbors, the construction guys took the day off too. Dandelion, a beautiful survivalist when your warmth is mistaken for the signs of a poorly kept lawn. Drink up tonight, earth, any day could be your last, and it is always best to die with a clean conscience. I hope you'll outlive us, and also forgive us. Not getting ready for judgement day, just a day without judgement, for your poor dumb children.

Pastoral (4)

Steamy hot day, iced tea, smokes. A white Bronco hums on the curb, windows open, arms dangling outward. A heatwave for two weeks, above 100 degrees. Global warming. Is there a poetic way to write that phrase?

The central a/c cranked down to 72 kills the earth with every bone chilling watt. My lover planted yellow flowers in the dead spinach bed. They're poisonous but what isn't nowadays?

I breathe deep, not much pollution in Nebraska, at least not yet. Will the earth outlive me?
Don't know. I just look down to the crab grass and weeds and then up to the huge blue sky and say: Please.

The Stylite

Albuquerque, NM

2019

View of The Sandias (1)

Rotten soymilk in my bran cereal, who knew that was a thing? The pharmacy fights with my intestines in little microbe skirmishes. Poplar trees green and lush, the freshly kempt lawn of my apartment complex, envy of those who can get their brows sweaty today. Who would have ever thought I would miss a straight job? The wrench to pipe, the shovel to earth, the math of a hammer's arc.

On the fifth floor we don't see people, we hear people. Sometimes kids playing, sometimes rejoicing lovers, sometimes middleclass fist fights. The harmony of domesticity.

A queer poetry book survived the rainstorm last night with only a slight warp, something all fags, dykes and trannies need to learn to escape assimilation.

My lover calling into work, my dog begs for pesticide. I, the lazy bones, wish for arms strong enough to swing a crowbar at the King's head, disrupting the prairie of his mad skull.

The Exhalation of Angels

Hot rain on concrete, it's been said in a million poems but how can a city poet do anything but rejoice at the car crash of nature versus capitalism? The pollen in New Mexico makes my lover's noise shudder, constriction of lungs and her head a construction site. Me? I just wait for the butterfly's return.

Narcissism is Wasted on the Young

The smooth faced beauty of a young male with a head full of hair. Acting unaware, avoiding rich faggots who wanted a trophy to add to their collection, snobbish and survivalist on my part.

Now I'm a bald forty-year-old transwoman with pores like shaky fingered acupuncture. A rugged woman, calling herself a handsome woman on good days with the help of low lighting. I've lived all over the place but most of my adulthood has been spent in the desert. No, I'm not a tough Edward Abbey type or radical leftwing gun enthusiast. I'm just an old Irish girl from the Midwest trying to find peace with middle age by drinking gallons of sun tea with sodium drops, occasionally choking.

Broken Homes, Broken Prose

My hermit self,

another phrase to indicate loneliness.

Had some friends down from Coyote, NM,

think I yabbered too much about yellowed pages

but hopefully things weren't too torn

to erase a return trip.

All my loved ones live in the Southwest now,

can we find something

more luscious to name them besides

'Created Family'?

Too clinical.

The desert is not clinical.

It's the migrant families looking for asylum

other than laboratory cages for animals

in a country where the lunatics run the asylum.

Agoraphobe

I fear for when my wife leaves the safe and secure
building we live in to run errands. I'm not afraid of
the gang life we see on T.V., always with brown
faces, not coincidently. I'm not afraid of a tweaker
carjacking her three-year-old Honda. I'm not afraid
a one-legged veteran will ask her for a dollar. I'm
horrified of a middleclass white male in his forties
with a sniper rifle drawing a bead on joy.

All American

I own a pair of one hundred-dollar sweatpants,

American made at least and they're thick enough to

absorb my urine stains. In the desert. In the

summer. With an x ray sun. I'm wearing a pair of

one hundred-dollar sweatpants.

Land Mine

A friend bought us a Chimayo pepper plant. It wilts on our kitchen counter. Too much catastrophe the last couple years to spark us into planting it. We've got the soil and the pot is selected. A plastic green jug to nourish it with milky water. But we stay complacent and lazy, just like those who retreat from disaster when they should be charging towards it. But I'll say this for the wilted Chimayo plant. On one of its stalks is a miniscule taste, waiting to make us scream.

View of the Sandias (2)

We have a perfect view of the sunrise, colors so beautiful they become cliché. Then the long unemployed day. When the reflection hits them bruised in the evening I realize my time has not been wasted.

Meat is Gorgeous Murder

Now that I'm a vegan wimp my farts smell worse, my energy level is worse and my mood is worse. The lard sheen of Modelo's tamales cooked on the wrong side of town makes my tongue weep.

A Den of Lions

Bought some black out curtains for my studio so I can sleep whenever I want, ssdi luxury. Smoke as many cigarettes as I want, drink as much coffee as I want, get angry at Spinoza whenever I want. Thoughts are not found in obscurity. They are found in the cross-eyed cat's lsd mind who has taken over our alley. His vision of soaking up warmth and not giving a damn is a lesson. A lesson the rich and disabled know. A lesson we should all know. A lesson my seventeen-year-old dog should know as she's dragged half dead around the black tar streets, and I'm awaiting the critique of her turd.

Rough and Tumble Glitter

All those hetero nature poets.

All those homo city poets.

I claim both.

Because I am both.

Property is Theft

Forty acres of tainted land just outside Madrid, NM. 35,000 dollars later we find ourselves stuck with Chollas and Mesquites and some meth dealing neighbors. Making plans, making dreams. My wife wants a flushing toilet. I want built in bookshelves. Haven't dug a well yet, haven't laid a foundation. Hell, we haven't plowed a road yet. But it's ours, as much as Communistic Capitalism allows. Peter Maurin, I thank you for easing my white girl guilt. Rousseau, I forgive you for being such a stuck-up prick.

All is Vanity

When I was young and beautiful I dreamt of being discovered as a movie star. I kept this want hidden from everyone of course, the shy ones always have the biggest egos. Now my Ramones shirt barely covers my gut and I marvel every time a woman or man of any stature smiles in my direction and realize that gas stations security cameras are the only screen presence I need.

Addictions are Fine

Sleepy eyed, only unconscious for a couple hours last night. The middle of June, the beginning of the real summer. Decaf with AA creamer. Menthol cigarettes. A made bed with a cowboy hat sitting precariously near the edge of the mattress, to shade my eyes enough to get a little daytime sleep. The rasp of my lungs reminds me of dead Marlboro Men. I've already given up so much, smokes may be the nails in my coffin but I will be safe and secure six feet down and gasping.

View of the Sandias (3)

Reading Rilke, who taught me everything I ever
need to know about love, though it took about
twenty years for it to sink in. The purple dusty
crags diagonal to my focal point, instead I'm staring
at our neighbor's lime bush and catching Ella
Fitzgerald whispers through an open window. My
lover comes out to greet me after work, and we
embrace each other, endure each other, outright.

Sketches of Bathers as an Old Woman

My gut rises like a sick moon, ingrown hairs and all.
Miss the half crescent of my youth, when I could eat
three pizzas from Valentinos without gaining a
pound. Now it's borscht and ginger tea with no
sugar which means no joy. Getting old is horrible.
Getting old is triumphant.

Impression (1)

National parks ready to be ravished, not sexy but rape style. My dad was a schoolteacher so we had the summers free when he didn't have to paint houses to pay child support. We camped everywhere, never staying in hotels unless we were lost at three in the morning.

My favorite was the Badlands Park in South Dakota, ugly and harsh, desolate and holy. Now everything is ugly, harsh and desolate, minus the holy.

Lithograph

Bill Ford, an unknown Sante Fe artist from the fifties that studied with the greats but who no one remembers has all his estate for sale in a little ramshackle house in Madrid, NM. I've got etchings, prints, drawings of his all over my house. What a gift to a forgotten artist, to have his work decorate the home of a never was artist.

Hello

Waving to the nice flannel lesbian in our building as she waits for me and my dog to move on. Her dog's a little riley so we keep our distance, though waving is friendly enough. This is at about 5 AM, before all the retired drunks are up. She's asked my name about five times and each time I tell her 'Abbie', she looks confused, eyes over my awkward body. But that doesn't matter, nor should it. It's just our neighborly niceties before the sun rises that keep us long distance friends.

An Impression Left on my Heart

There's mostly gravel lawns around my neighborhood, all well kept and manicured. Hell, even the cracks in the sidewalks are devoid of green. Miss the lushness of the Midwest, which really isn't that lush. The swoon of a raggedy lawn with toys and animal shit with grass six inches high, my childhood exactly. Raggedy and shitty, my twenties exactly.

Washing Tub

Fresh and naked from the shower, clean shaven and ass clean. Degas would throw an erection my way. Sun pollutes through smoke grime windows. Tips of unknown foliage stop my screams, cork bottle of Uptown Albuquerque with a porn shop on the corner bringing down property values and thank Elohim for that. All the Impressionists hired prostitutes for models, as if that were a bad thing. The unflattering compression of a woman's stomach who has known lust and survival, the womb of a new Jesus. All artists think they are God. I'm waiting for Jezebel to show up and splatter paint on the whole damn scene.

View of the Sandias (4)

Bloated on angel hair and mushrooms, fungus and pseudo-sacred gives me a good carb high. 92 degrees outside. My dog can't make up her mind and alternates between sunshine and shade. Clouds full of seraphim, waiting for their bowling league to show up. False alarms of thunderstorms, the mountains dry as a tooth socket. Cezanne and his mountain, his only obsession besides nudity and no that's not a bad thing. My fly is open, forgot to button it after taking a leak, fumbling with my jeans so I don't get arrested. A yellow jacket buzzes around, inches from my face, reminding me that we are always in danger, no matter how many hours a day we spend staring at screens to get our minds off this terror state. Rub the goo out of your eyes and glance towards nature. It won't be around very much longer.

Blind

Cancer sun through patchwork quilt mosaic, given to me by my lover six months into our relationship. Now I use it to block out the sun, self-imposed misery or just a concern for my skin texture? A candle, flame, sun simile, burns creative and sweating from doing sit ups. My neighbor below me coughs, letting me know not to be too artistic in my yelps. The sun is shining. The sun is shining. Let me rip open drapes and die a pale girl life.

A View of Michelle Obama's Sleeping Quarters

The Plaza Hotel in Las Vegas, New Mexico. Tourist trap I know, but I don't mind being a middle-aged wealth voyeur every once in a while. Took a vacation from soymilk and tofu. Charred green chile burgers and cheese sputtered beans. Fuck yeah. Stayed up all night, finished two books and saw the dawn before taking my crazy meds. The impression is not flattened or pale. It is an electricity that will shatter the grid.

View of the Sandias (5)

Poplars hatching seed bombs on the concrete, the Sandias dusty and eye floaters. Seeing an eye doctor this week, to see if Macular Degeneration has truly passed down over the years or if I'm just imagining/not seeing things. The light murk mountains. I want to see.

Machine

A red candle burns for murder/creativity. A
guardian angel keeps watch over the whole thing,
guarding me from going too nuts. Smoke after
smoke, blurred Polaroids and a copy of The Brothers
Karamazov sit on my bed stand. Antisemitism and
art, Allen Ginsberg evens it out with Planet News.
Magic dirt from Chimayo, NM in a green bottle,
genie to cure to my sparkle/grit brain. A
lawnmower outside my window mutes us all.

The First Supper

Made chili today, hippy quinoa and pinto beans and New Mexican hot red chile. Visiting the bathroom a lot but all food has it's utilitarian aspects. My friend says there're only six harvests left in the soil for crops. Cannibalism here we come, as if we're not already eating each other alive while the fascists laugh in their high security mansions. Have a meal and share it with others. Cook a meal and slob it all down by yourself. The choice is yours.

Impression (2)

A bass guitar sits on a cheap stand, short scale so not much range but the color and shape are beautiful. Four strings saved my life once. Four winds saved our lives once.

Find Some Humility

The neighbors next to us put up pigeon fencing all over their balcony. They're enclosed by the fear of humble droppings. We're city dwellers, shouldn't we welcome a little bit of nature even if it's five floors up? Shit stains on our terrace, cigarette burns on outdoor carpet. Potting soil impotent because we've had so many failed gardens, even though this time I've promised my wife I'll water them, the basil, the tomatoes, the jalapenos. Am I lying? Are the pigeons dying?

View of the Sandias (6)

Police sirens, the Sandias a thin blue and black line at

five am. Mastiffs and rottweilers sing in unison,

rough orchestra. Sounds like the whole squad's out

as the sirens swell and grow and tires screech and

right now, at five am, with blue/black Sandias,

someone is dying.

The Stylite Wonders

What am I learning as I look over my terrace? The gossip of my neighbors, usually friendly and not too nasty so that's a good thing. My neighbor Ron's registered smoke breaks. The developing agaves that just got planted. My fear like an ocean rumbling inside my chest, anchoring me to the spot.

Yellow

About to light a candle for anger, to learn its possibilities and useful machinations. My lover in my twenties would be grateful, me screaming at him in asphalt Phoenix. My girlfriend in high school would be happy, me berating her to shreds. My dead mother would be happy, me spastic and shaking on the front lawn. My guardian angel would be elated, watching my stenched ego flush down the drain.

The Lazy Painter

Sweat sheen, no oil, no turpentine, just sweat. Out on the terrace in late June, a thunderstorm hints the distance. Wind blowing over my butt can, a green couch's pillows flop and flip like rubber novelty fish. My hands on the railing, looking down to see an empty street. I've never heard anyone complain about the weather as much as I do in Albuquerque. Seems perfect, not too hot, not too cold. My lukewarm heart aches for Elohim, hoping s/he'll take me as I am on these boring days, with lightning in the background.

Teenage Jesus Superstar

A yellow candle burns for my punk rock youth, Big Boys on the stereo. Music saved my damn life, no joke. 25 years later I still find myself screaming but this time I can't tell if it's on purpose, MI or passion? Too much coffee or products of a well spent youth? The sweat beads up on my forehead, still performing after all these years but this time with no crowd to boo or cheer. Screaming into silence, my mouth is still shrapnel.

Date Night

Yabbering heterosexual neighbors, talking about piss stains on the lawn or the new landlord's lack of concern with rising prices and no improvements. The gays next door gaggle at nighttime, waiting for their youth to go to waste. Us lesbians just wear sweatpants and fuck each other every Thursday.

Impression (3)

Blurry clouds seen through glaucoma eyes, going to see an eye doctor on Friday. Afraid of retinal injections or the bad news that pretty soon I won't be able to read fine print anymore. Berthe Moriset's shabby chic upper crust in my vision, her well groomed youth and ladies have nothing to do with me or my childhood. I cut the canvas, still a feminist but man was she boring, just like this poem.

Gaughin was an Imperialist

Will the rapist of the Earth (we all are) get another term? Probably. I donate about 25 percent of my tiny income to close elections. I write political poems whether they contain the anagram USA or not. I don't eat meat and light candles for Saint Jude. I VOTE. It doesn't really matter. The most American man ever created is in the White House. Paint that building baby shit green and maybe we'll finally be honest with ourselves.

Impression (4)

A plastic nun figurine inherited from my wife's mother is holding up a banner that says 'Have Faith'. Please let me feel that, believe that. Weep over that.

Lazy Bum

Cleaned the house today, ate three meals all including carbs and it's not even 10 AM yet. Jerked off, made the bed, doodled around with screens, had several bowel movements. By noon I hope to get down on my knees and pray, with the sun shining, with birds screeching, with automobiles backfiring, and try not to ache for this country's losses, even if they're not quite lost yet.

Toullesse-Lautrec: Women at a Cafe

Joy at midnight, blackout curtains stop the lights from the car dealership from keeping me awake. Sending messages to my best friend, joking back and forth. I miss her. Both of my best friends are in Arizona now, one in Tucson the other in Prescott. Miss the Saguaros and Barrel cacti, the sun's a bit much though. After all these years we keep getting farther and farther away from our Midwest roots. Let a blizzard come and make us wrap each other in warmth under a wool blanket and remember the glee of being three dumb kids.

Lighten Up, Vincent

Today the dictator's voice wasn't in my head. Today I didn't check my email or give any money which I don't have to worthy causes. Today I cleaned my room and watched old sci-fi films. Today I ate potatoes, carrots, pasta with generic sauce and drank gallons of sweetened lemon iced tea. Let him have the world of killing. We possess the art of living.

www.ingramcontent.com/pod-product-compliance
Lightning Source LLC
Chambersburg PA
CBHW031924170526
45157CB00008B/3038